Northwest Na[tive]
CreativeColors 2

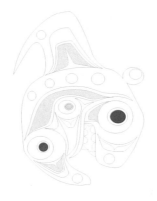

Written and illustrated by
Robert E. Stanley Sr.
The House of Ni'Isyuush

hancock
house

ISBN-13: 978-0-88839-533-7
ISBN-10: 0-88839-533-7
Copyright © 2003 Robert E. Stanley Sr.

Second printing 2005
Third printing 2007

Cataloging in Publication Data

Stanley, Robert E., 1958-
 Northwest native arts : creative colors / written and illustrated
 by Robert E. Stanley

 "The House of Ni'isyuush".
 ISBN 0-88839-532-9 (v. 1) — ISBN 0-88839-533-7 (v. 2)

 1. Nis_ga'a art—Technique. 2. Indian art—Northwest Coast of North
America—Technique. 3. Animals in art. 4. Color in art. I. Title.
E78.N78S722 2003 704.03'970795 C2003-910239-4

Printed in China—SINOBLE

Editing: Yvonne Lund
Production: Robert E. Stanley Sr.
Cover design: Theodora Kobald

Published simultaneously in Canada and the United States by

HANCOCK HOUSE PUBLISHERS LTD.
19313 Zero Avenue, Surrey, B.C. Canada V3S 9R9
(604) 538-1114 Fax (604) 538-2262

HANCOCK HOUSE PUBLISHERS
1431 Harrison Avenue, Blaine, WA U.S.A. 98230-5005
(604) 538-1114 Fax (604) 538-2262

Website: www.hancockhouse.com
Email: sales@hancockhouse.com

Contents

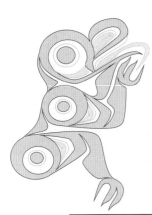
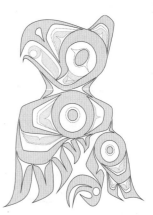

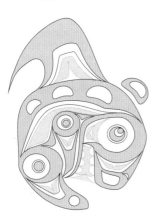
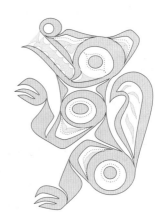

Acknowledgments

I would like to thank Peter McKay (hlgu-ayee) for his linguistic assistance with the nisga'a names and to everyone who continually give me encouragement to write and illustrate my books. I received a lot of inspiration from different people.
I thank you all from the bottom of my heart.
I would like to dedicate this little coloring book to children from all nations.

Sincerely,

Robert E. Stanley Sr.
2003

Introduction

I would like to start by explaining my intentions for this coloring book.
I created this book as a tool to teach children a bit about our
culture, and to show them the crests of our culture.
I wrote the names of each design in Nisga'a and English
The crests represented here have been passed down to us for
generations and will be passed on for many more generations
to come. This book is made to show the children
what colors are used in our native art and to teach them where
to place these colors. This would also give them a better
understanding of the basic shapes that are used in the art.

I know that this book will help native children better understand
the art of their culture and the heritage that belongs to them.

Sincerely,

Robert E. Stanley Sr.
2003

Legend

=== fill with black

=== fill with red

=== thin black line

=== thin red line

You will need 2 coloring pencils
1 black and 1 red and a pencil sharpener

The Split Grizzly Bear
bayt bahlgum lik'in̓skw

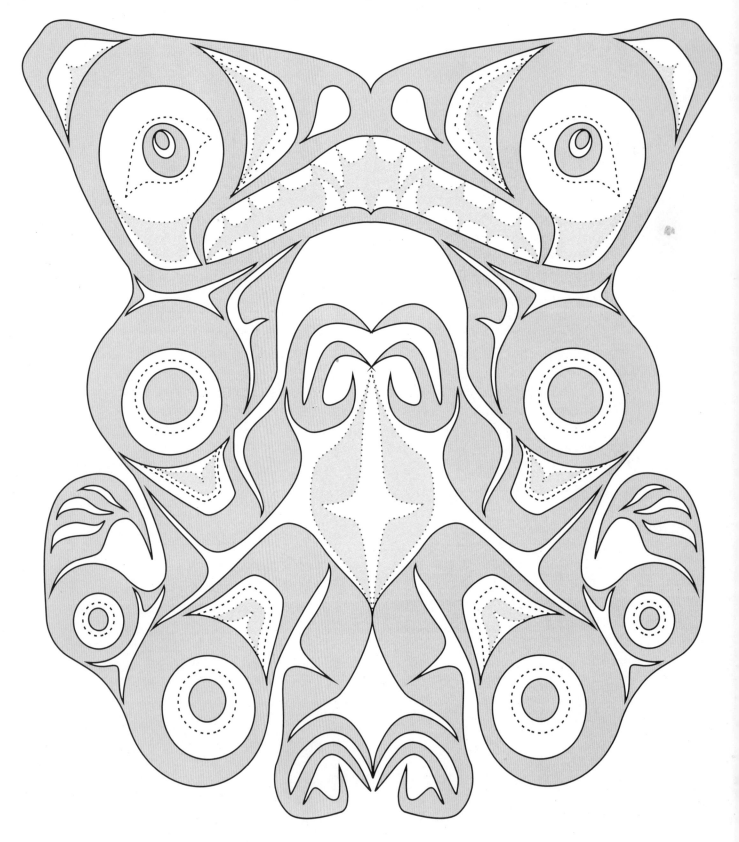

The Eagle
x̲sgaak

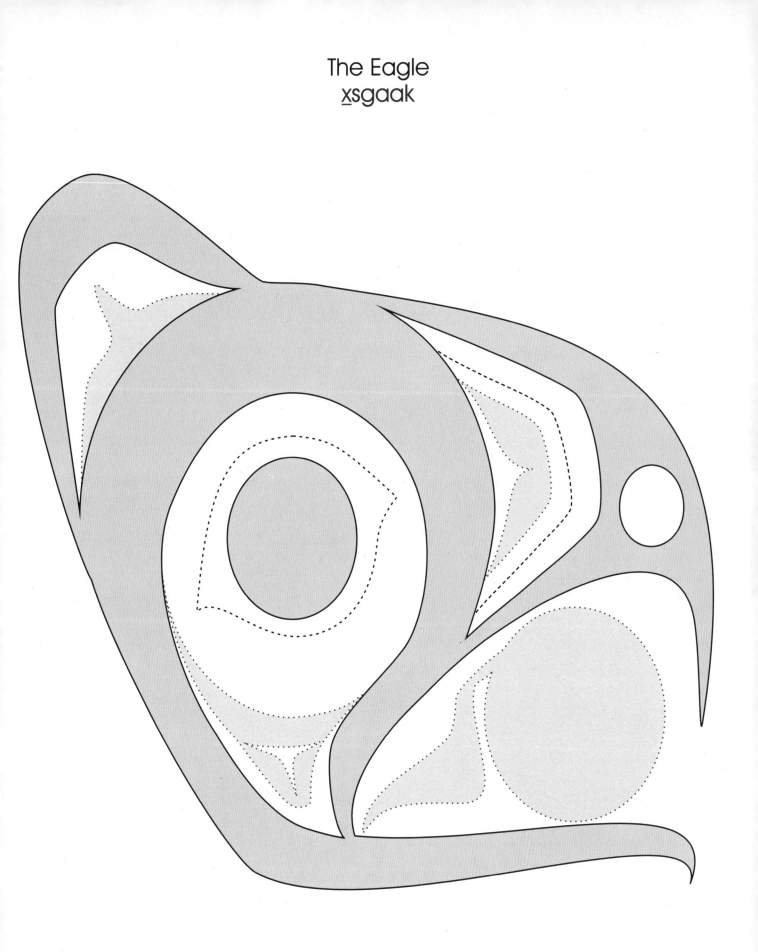

The Eagle
xsgaak

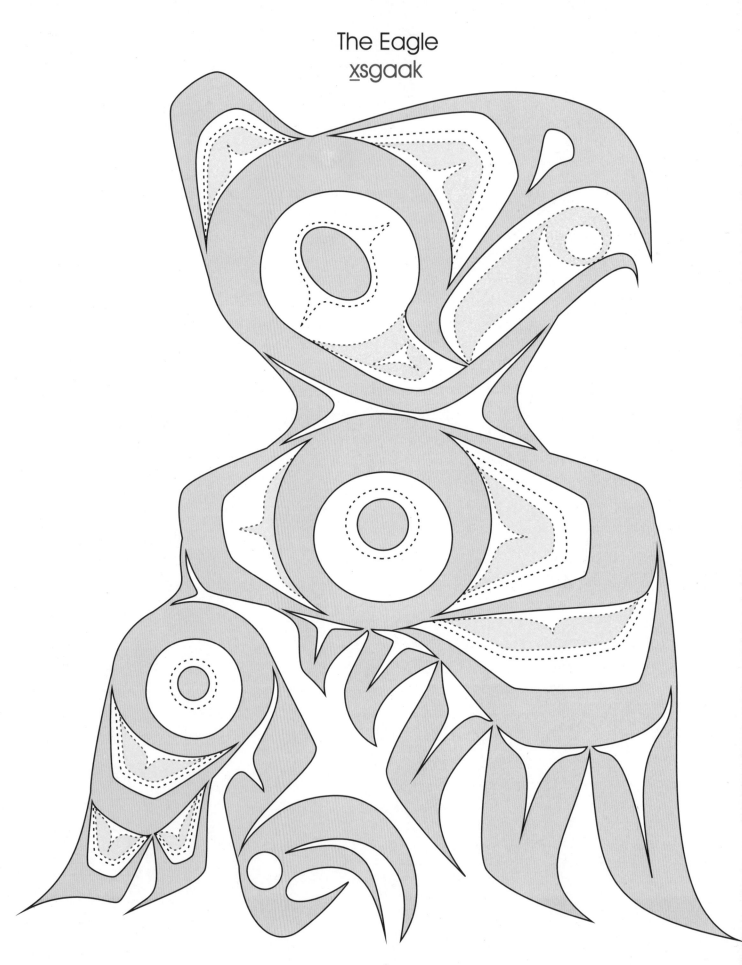

The Killer Whale
ńeek̲hl

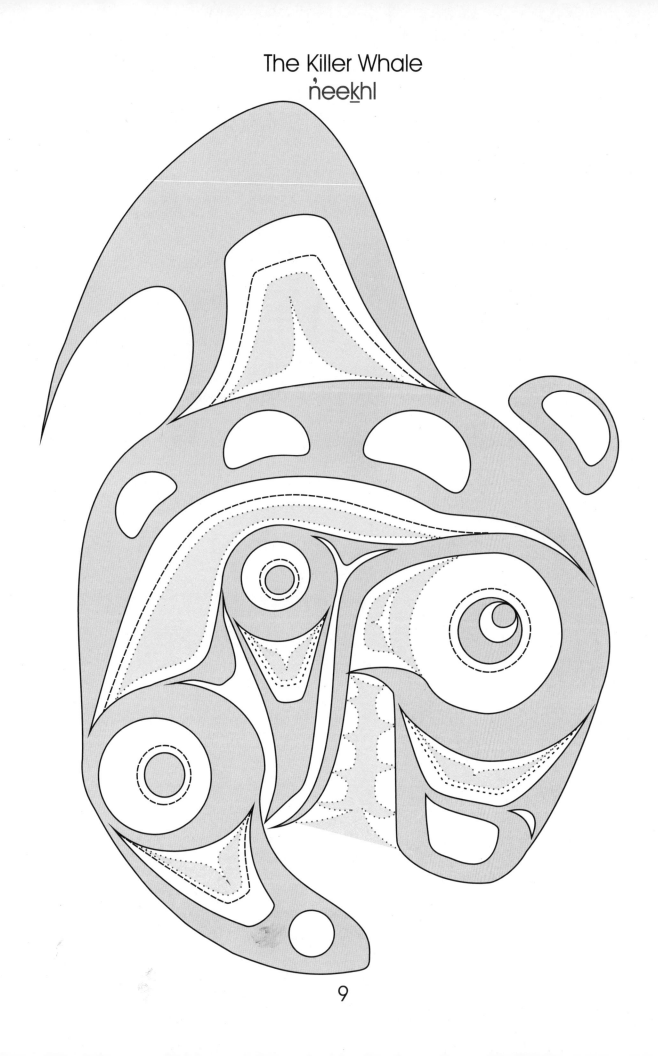

The Oval Eagle
<u>x</u>sgaak

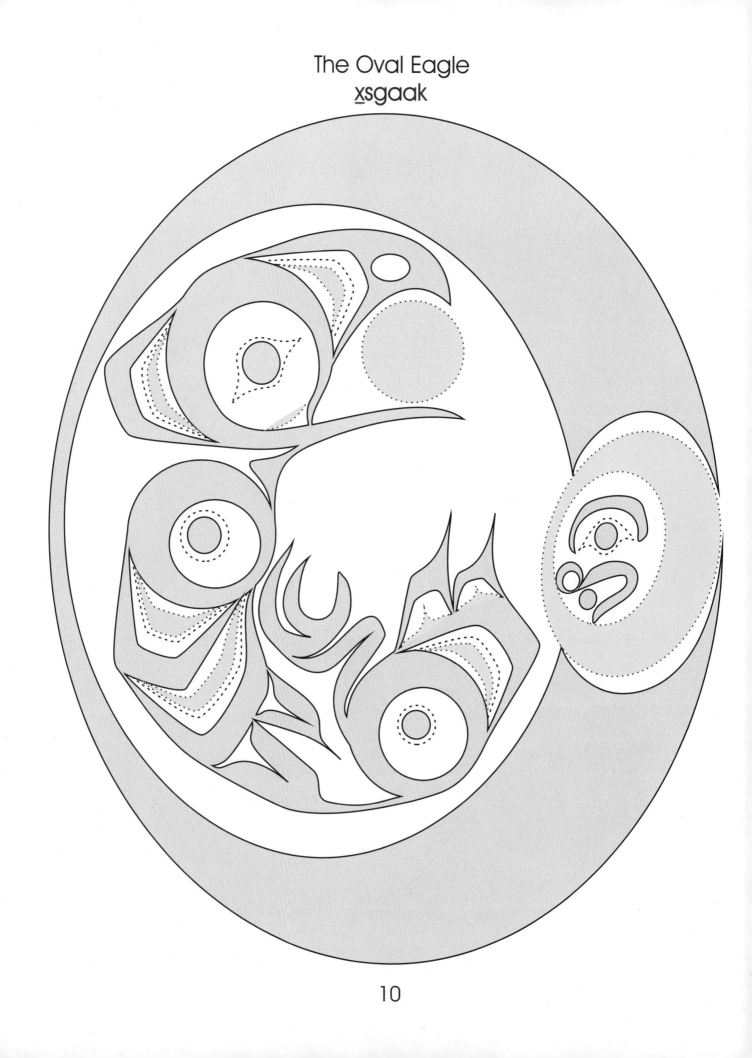

The Frog
g̱anaaẃ

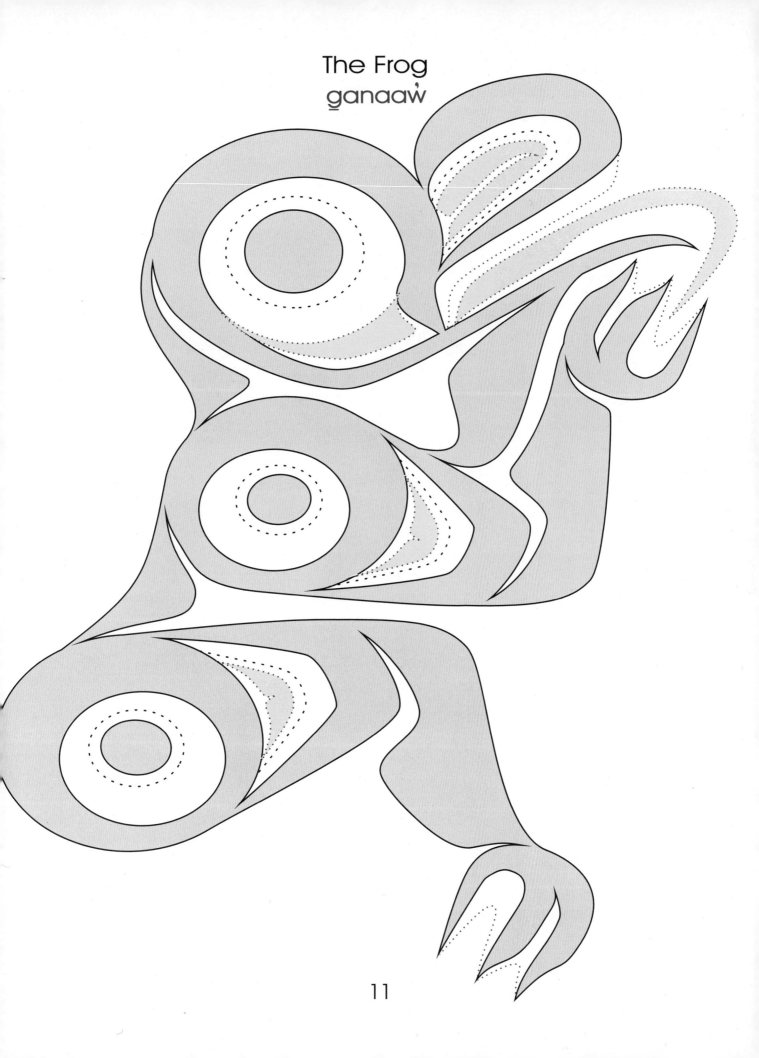

The Raven
g̲aa<u>k</u>

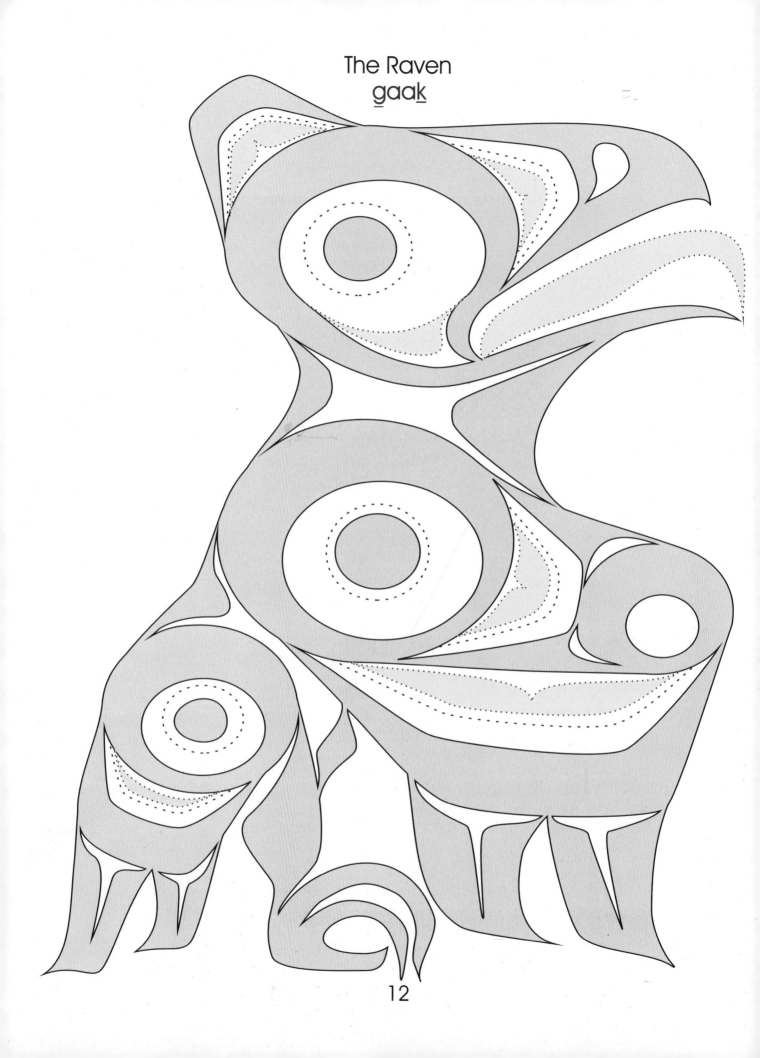

The Moon
hlo<u>k</u>sim a<u>x</u>kw

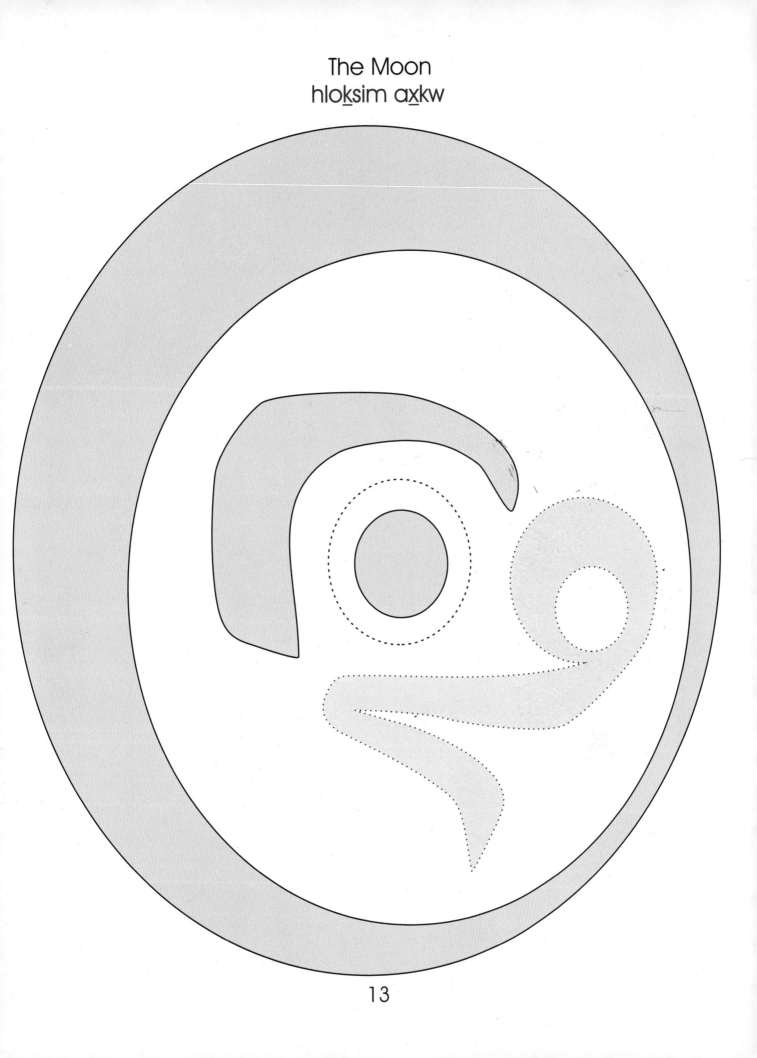

The Sun
hlo_ks

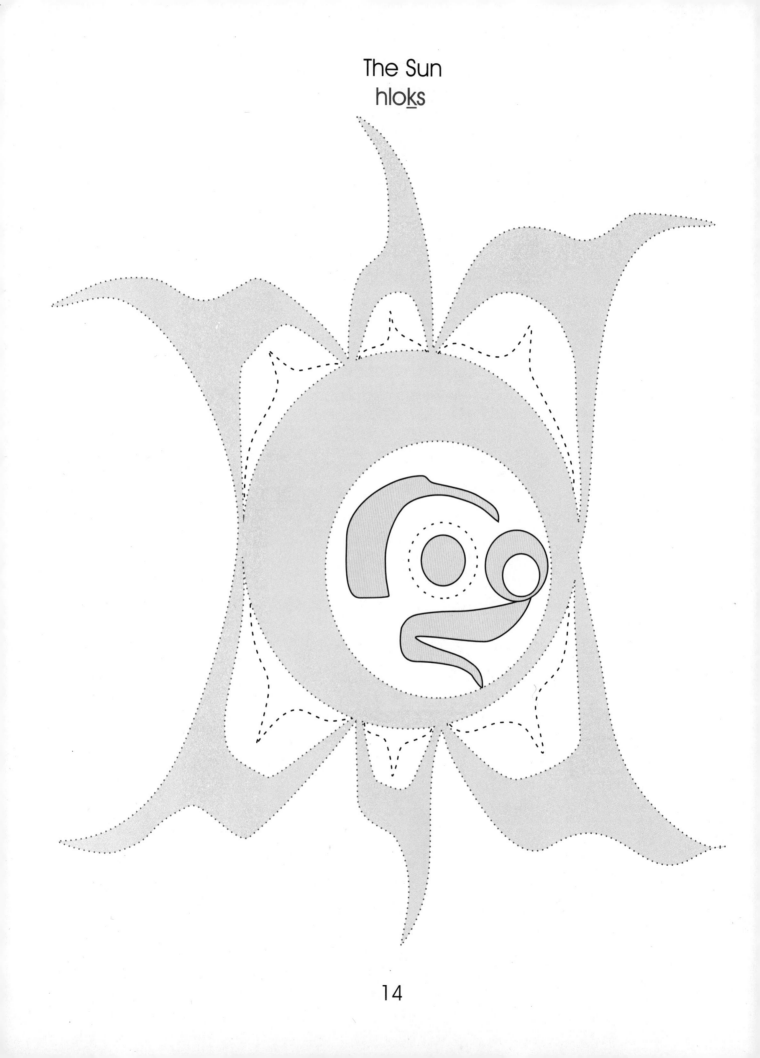

The Man
gyat

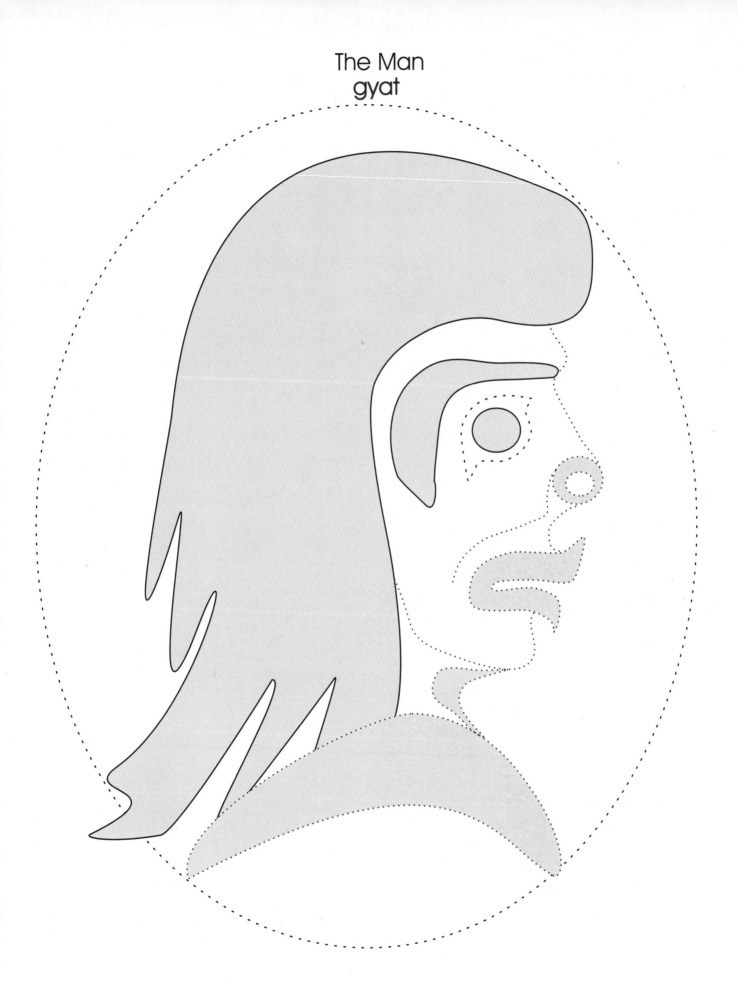

The Wolf
gibuu

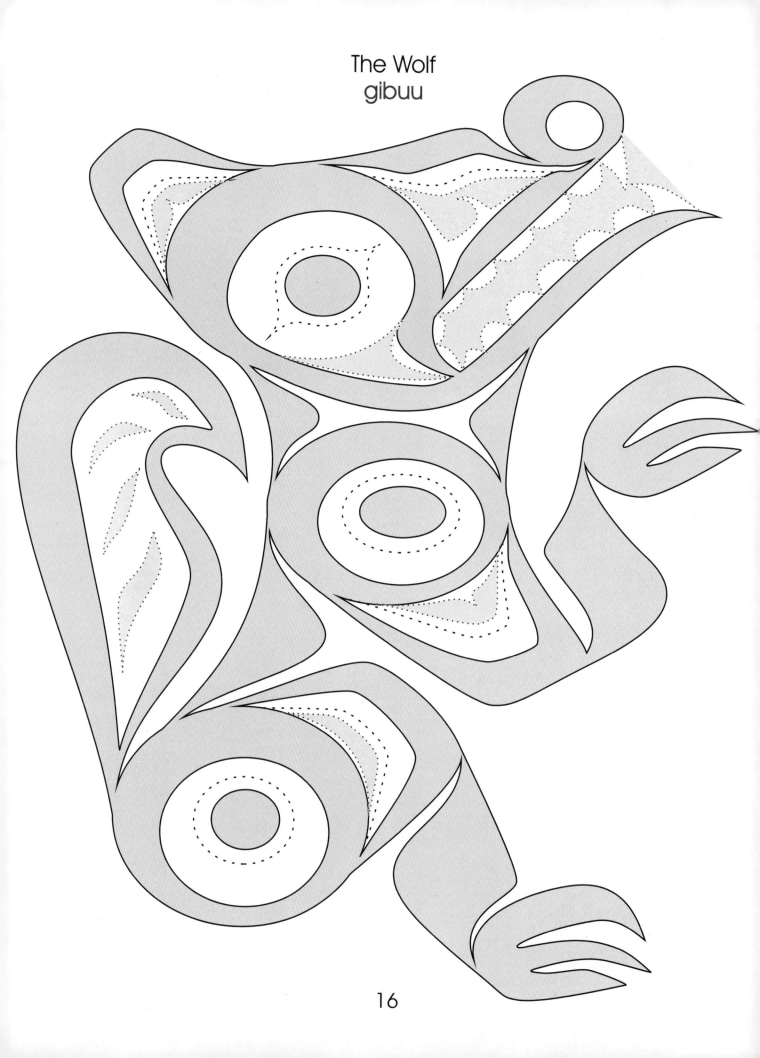

16

The Split-Frog
bayt bahlgum g̲anaaw

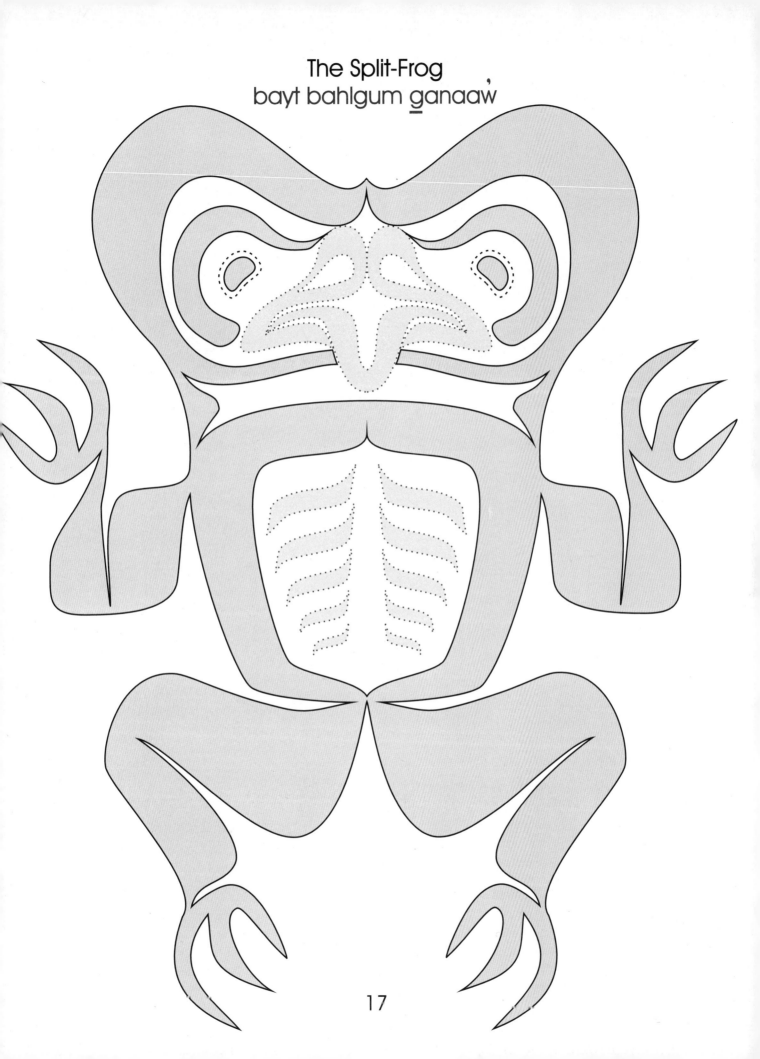

The Raven and The Sun
t̲xeemsin

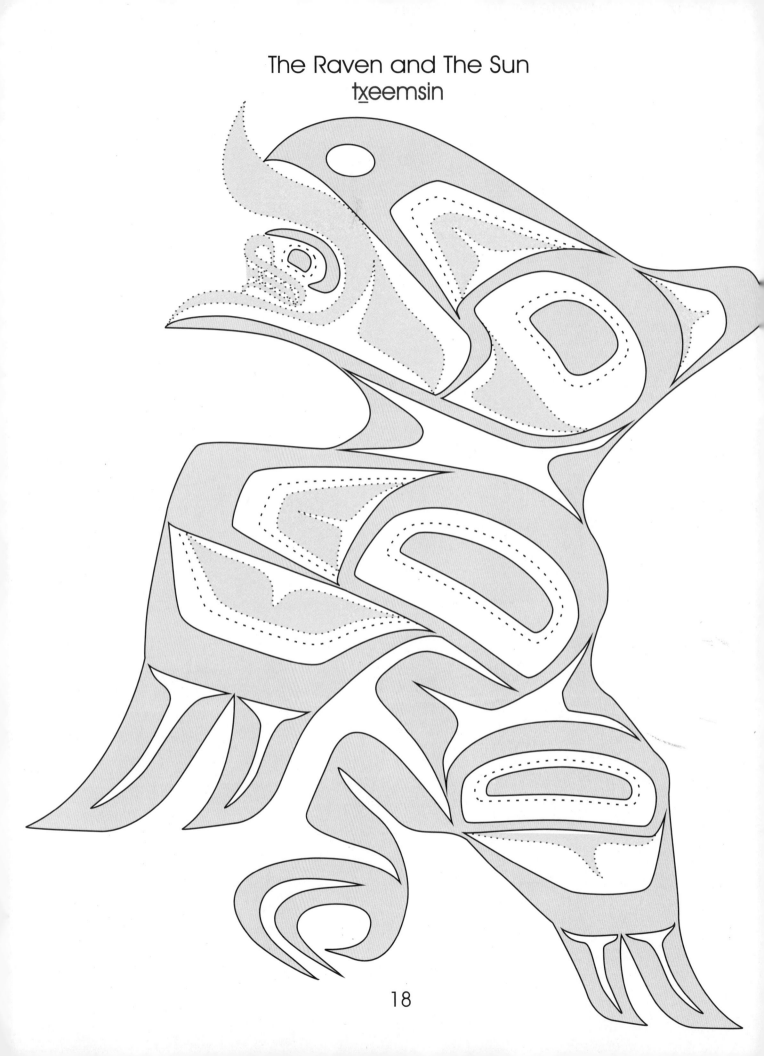

The Black Bear
ul

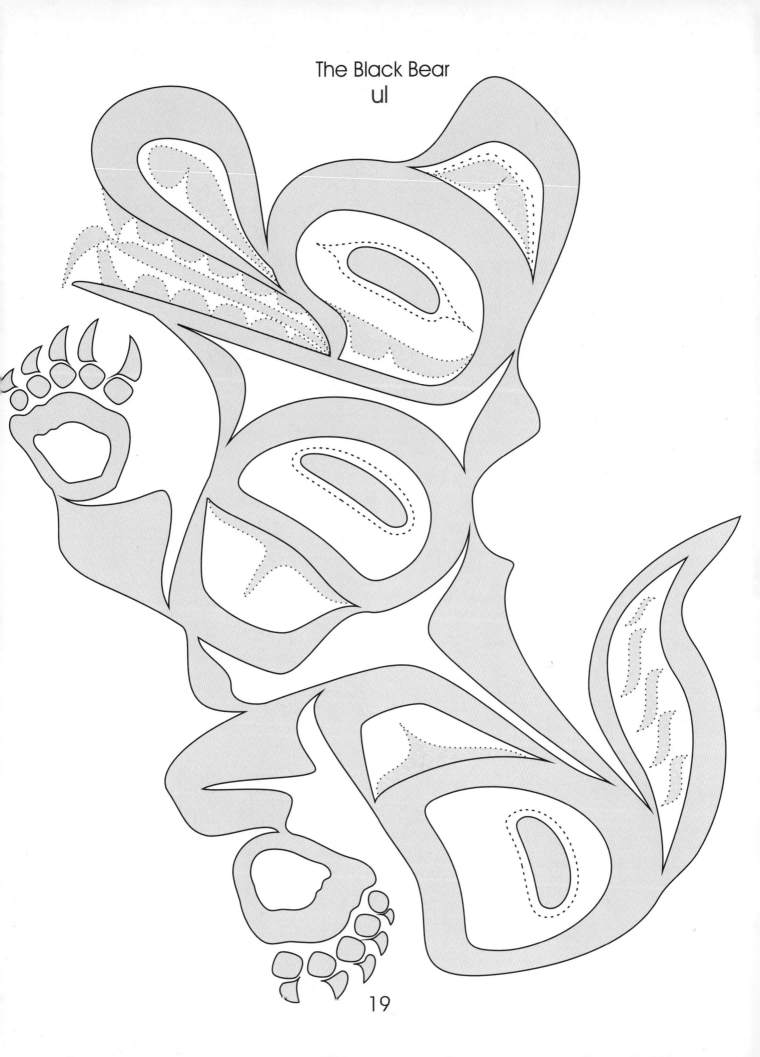

19

The Eagle
<u>x</u>sgaak

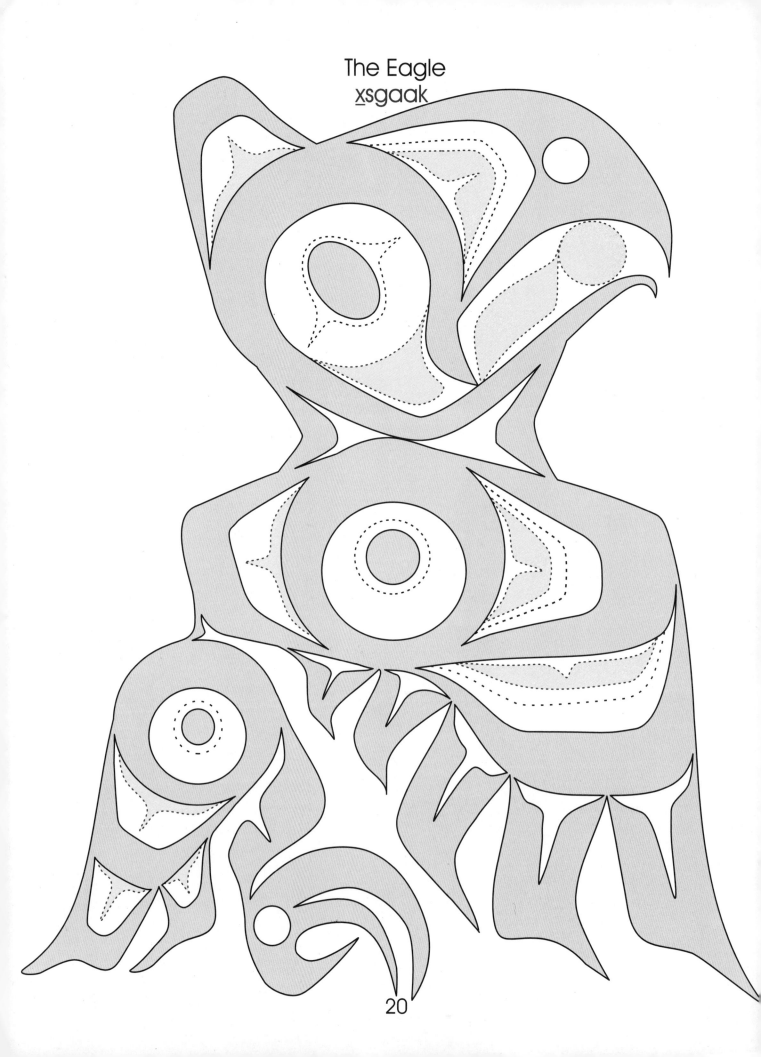

The Frog
g̲anaaẃ

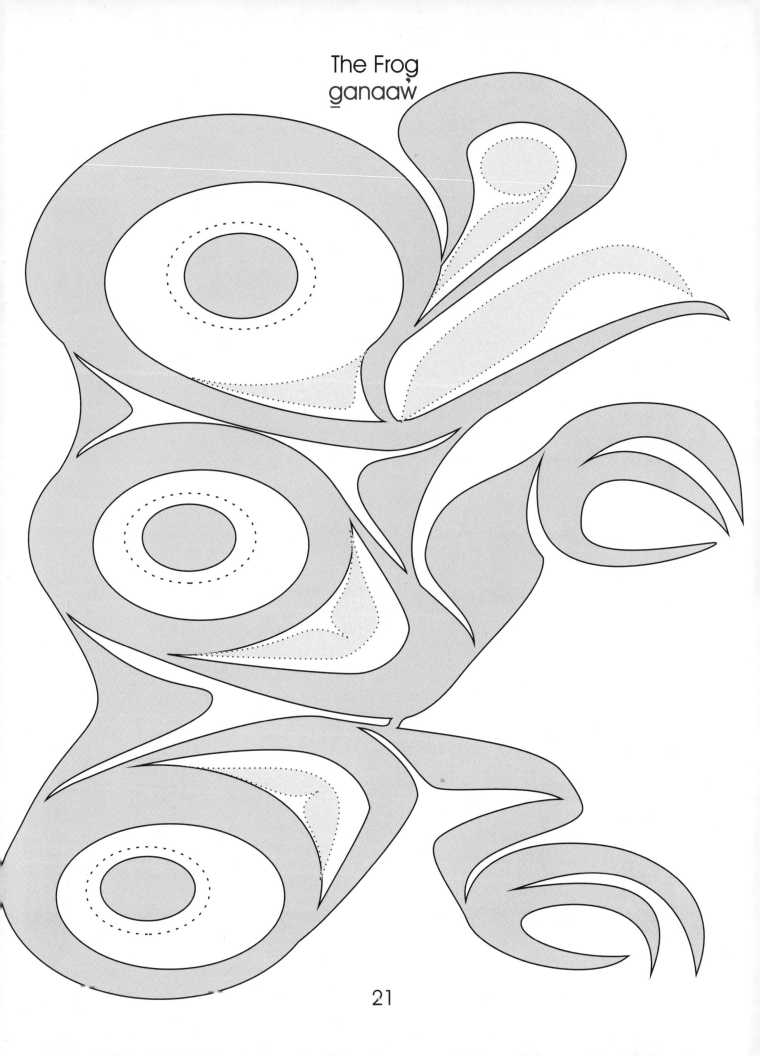

The Killer Whale
ńee<u>k</u>hl

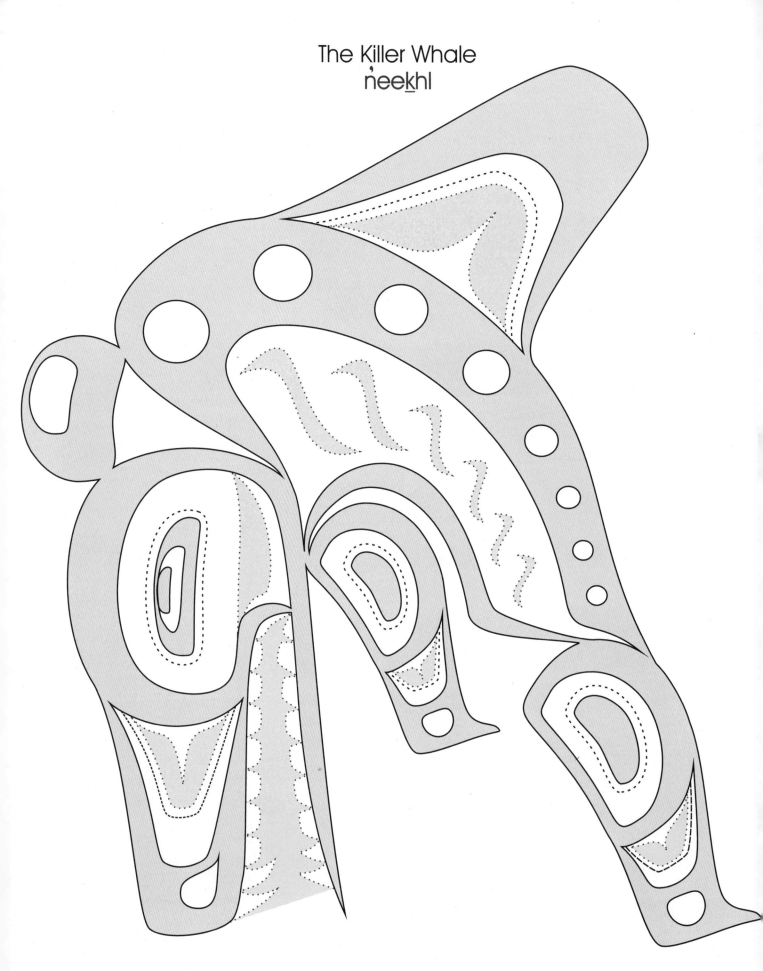

22

The Beaver
ts'imilx

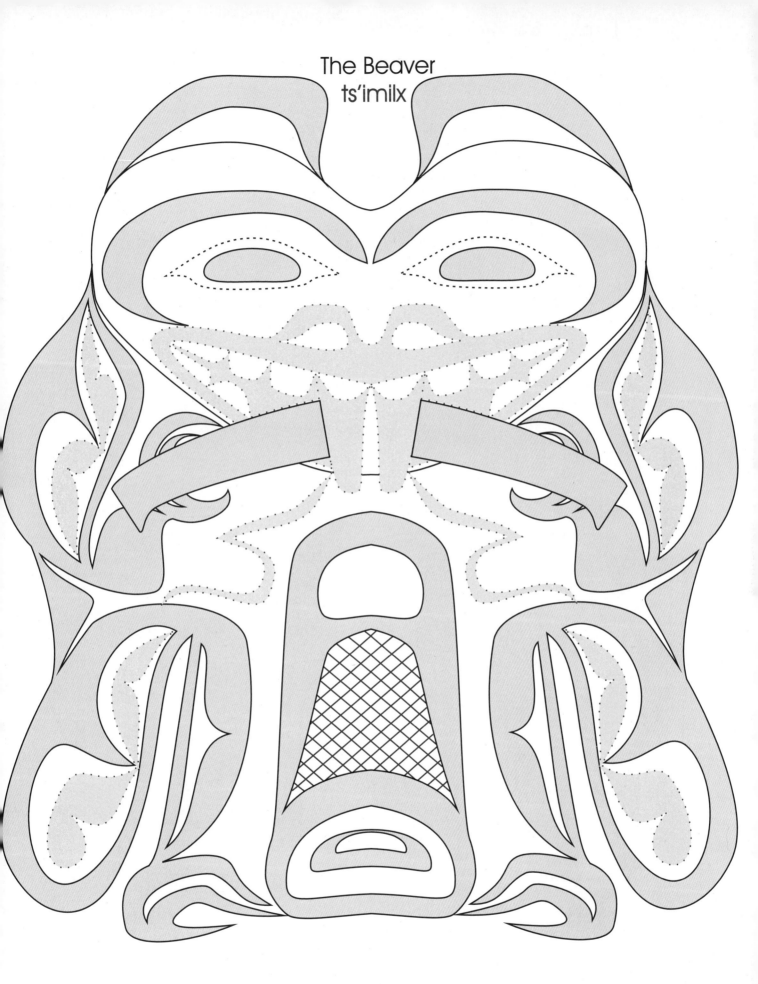

The Killer Whale
ńee<u>k</u>hl

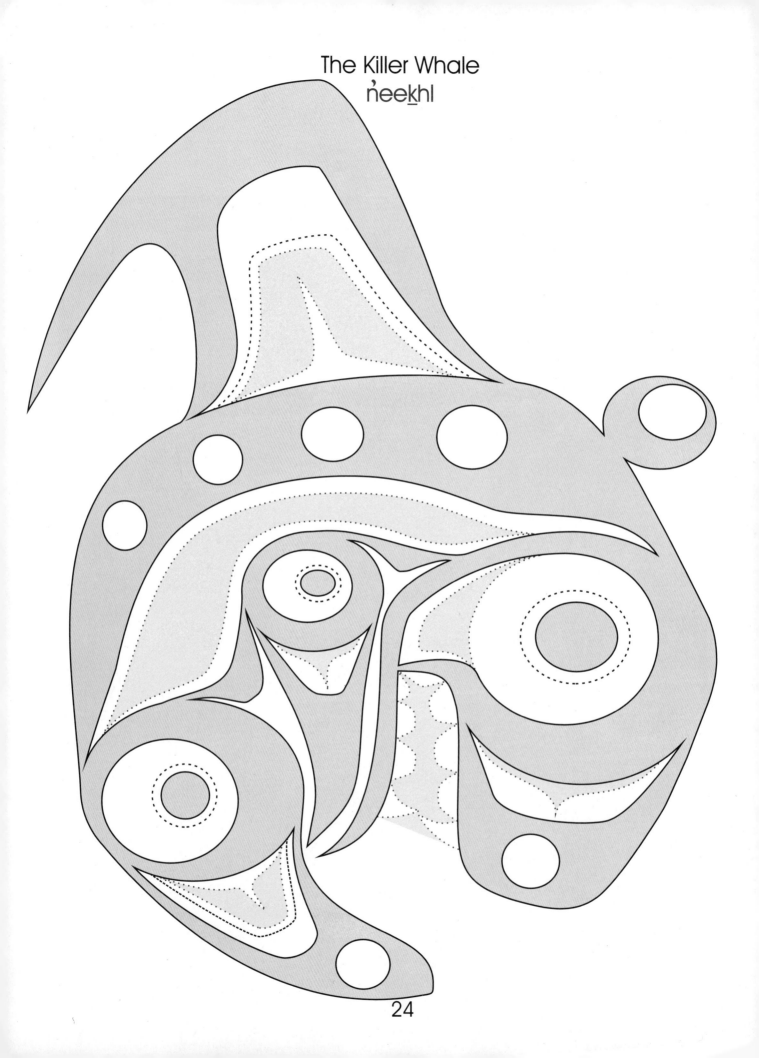